How to Draw People

EASY STEP-BY-STEP
DRAWING OF PEOPLE FOR KIDS
[*Basic Drawing Lessons*]

By Maribel Cruz

DEDICATION

To my newborn princess Adrija who has inspired me for this book.

TABLE OF CONTENTS

INTRODUCTION

Teaching children how to draw is about letting children express what they see through their hands. This book will inspire children to draw by letting them observe people in their surroundings and telling you what they see through creating images in their own version. Apart from teaching kids how to draw lines, it is also important to train their eye to be keen about what they see around them; obtain the confidence to recount what they saw in a non-verbal but distinctively elaborate manner. Children by nature are great at reducing the figures they see around them in a simplistic manner. The importance of building up their confidence should not be underestimated: there is a need for the tutor or trainer to always appreciate what a child creates.

This book is created mainly to teach children how to draw but several concepts of teaching and child development are incorporated in this book. Children will learn a lot about themselves. They will also become more aware of their environment by giving more focus on the people around them. Starting from the concept of "self", the child will have the opportunity to express his view of his self-image. He will recognize emotions that he feels. Then he widens his perspective to people in his family, his circle of friends and the people he sees in his community.

This book also presents career or work that a child may observe in his community. He will also learn how to identify what these people wear and express it in his own way through making lines.

In conclusion, this book goes beyond teaching children how to draw. Teachers can use this book in presenting different lessons in schools not only when teaching kids how to draw.

TO THE PARENT
OR TEACHER

Obtaining the maximum benefit of using this book requires some technique in presenting it to the child. It is not only the words that you use but the entirety of your presentation.

Conducting Pre-requisite Hand Flexibility Exercise

There are 22 step by step "how to" figures in this book. Before you start doing these exercises, you need to *introduce* several *hand flexibility practices* for your learner/s. Children are taught to write by making lines: vertical lines, horizontal lines, slanting lines. Then they are trained to make curves, circles and other shapes. All these practices enhance the hands' flexibility.

Overcoming Obstacles

You can maximize the guides and sketches you will find in this book if you know how to handle several difficulties that you may be facing when teaching kids how to draw.

Catching and Maintaining their Interest

This is of primary importance. Once you failed to catch their attention, you cannot let them start scribbling, sketching or drawing. One of the most effective ways of getting a child's attention is *talking about the child's personal circumstances* – start about who he/she is; their family; their friends; the people he/she sees and things these people do. That is why this book is created and orga-

nized with topics arranged in this way.

Present the topics in a story-telling way. This also implies know-ing as much background as you can about the learner. **If you are the parent**, consider the child's likes and dislikes. If you know that he does not like doctors, you have an additional obligation to make a way of presenting that in another manner or maybe choosing another figure instead. **For teachers**, if you know a child's family back-ground, it will help you in not unintentionally embarrassing the child. Do not let her draw a mom or a dad if you know that this will raise anxiety for the child due to her specific personal circumstance.

"I cannot do it" Excuses

Children are sometimes great at manipulating adults. So when a child says "I cannot do it", check clearly what the motive behind is. Is it to gain more attention? Is it because of laziness? Or, maybe the task is too simple for him. Sometimes the child is trying to push you to offer a reward so he/she will do it. Remember, giving reward is a good way of motivating kids but it should be given with caution – the value and timing of giving rewards are very important.

Keeping them Motivated

Praises work well. Nonetheless, do not overdo it. It might create a bloated confidence and you will soon find out that he/she does not want to participate. The child will not find the tasks challenging and might think that the tasks are too easy for him/her.

Also don't forget to let them color the finished drawings if they like.

DRAWING OF PEOPLE

This is Me - Boy

Boys should follow these steps. Girls should move to the next page.

It is always great to **start with a smiling face of you**.

- Observe carefully how the brows and the mouth are drawn to show different feelings.

- You may start by making the head with a circle.

- Make the brows like a slightly curved line and draw the mouth like a simple boat.

Draw the body by extending the lines down from the head.

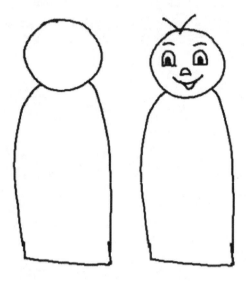

Now add the arms and legs.

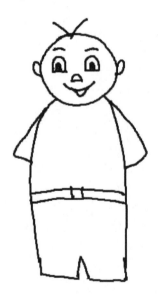

__Smiling face__: When I smile my mother will smile too.

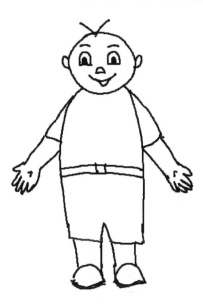

__Sad face__: Observe how the brows are drawn. The eyes and nose are drawn in the same way as the "smiling face". The mouth is a simple curve. If you reverse the position of this curve, you will then have a smiling face.

**Crying face**: Same eyebrows as for "sad face"; add the tears and draw the mouth like an inverted boat.

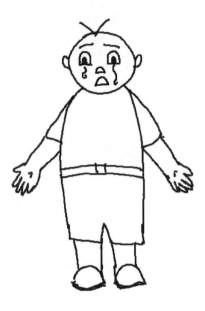

**Happy face** is almost the same as "smiling face" but make the mouth wider to emphasize "happiness".

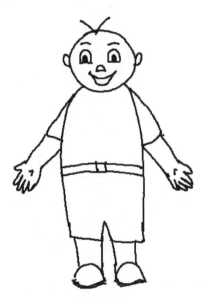

This is Me - Girl

Use the same procedure as making the head of the boy above.

Notice that the difference is mainly on the hair. You can make the girl's hair straight if you want it that way.

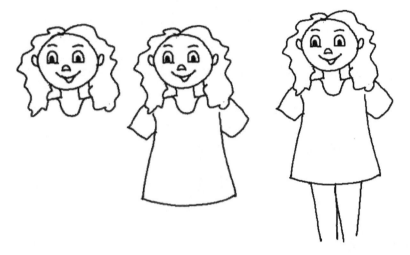

Smiling Face: This is me when I smile.

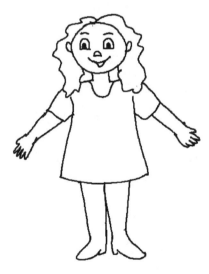

Sad face: Observe how the brows are drawn. The eyes and nose are drawn in the same way as the "smiling face". The mouth is a simple curve.

Crying face: Same as making the boy's "crying face". Same eyebrows as "sad face"; add the tears and draw the mouth like an inverted boat.

**Happy face** is almost the same as "smiling face" but make the mouth wider as for boy's "happy face".

My Family

My Baby Brother

Do you have a baby brother or a cute baby that you may have played with or observed? How do they look? Aren't they very cute when they sleep? *Let's draw a sleeping baby*.

When you draw people, **start from the head first then the hands and the feet**, then lastly the things around the person.

So here, we start drawing the baby's head by drawing a circle. Draw the details of the face: eyes, nose and mouth. Then proceed to the other parts of the body.

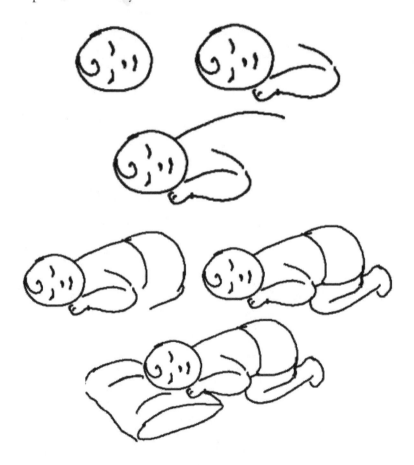

Note that the ears are not drawn. If a child is keen and raised that question, praise him or her for being observant. If the child did not notice that, raise it and draw his attention: "Have we not forgotten something?"

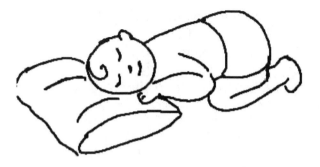

My Brother

Let's draw your older brother!

The face details – start it by writing "boy".

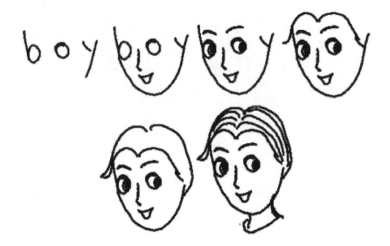

Draw the shirt, hands and belt. Observe the proportions.

We want to draw a boy who is running. Observe how to draw the hands and the feet.

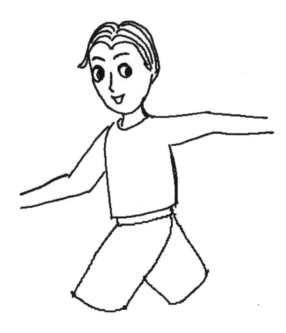

Let's draw the shirt next.

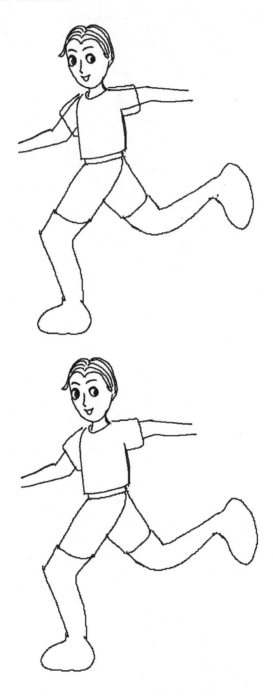

Finally draw the hands.

My Sister

Next let's draw your beautiful sister!

Draw the face first.

This is *how to draw the eyes*.

Draw your sister's hair.

Now let's draw the dress starting from the neck part.

The blouse details next.

Finish the skirt and hands.

Make the legs next.

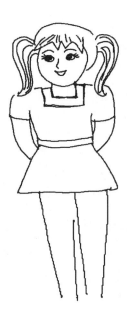

Draw the shoes and you are done!

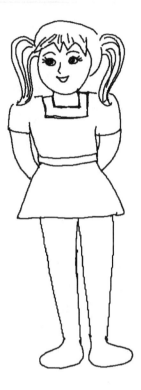

My Mother

Draw your mom with something that she usually does.

In this drawing, mom is seen carrying you or your baby brother or sister.

You can draw your mother holding your hands in a park. You may also draw her with her office or work clothes.

If you want to draw her cooking dinner, that is great too.

Start with the face first.

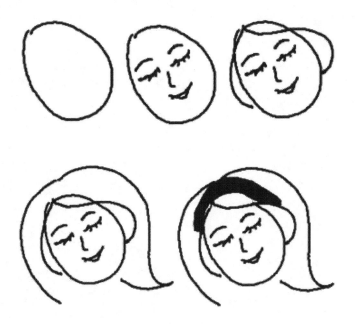

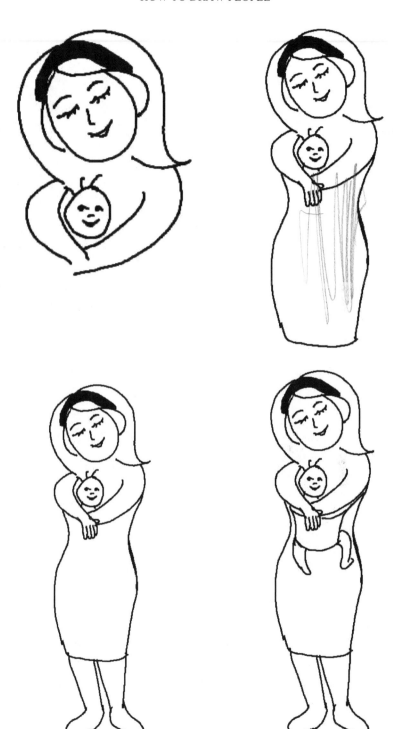

My Father

Here, we will learn how to ***make use of circles*** to set the proportion of what we want to draw.

Notice that you ***start by making two circles***. The second circle will be transformed and some portions will be erased but we draw it to limit the size of the father's trunk.

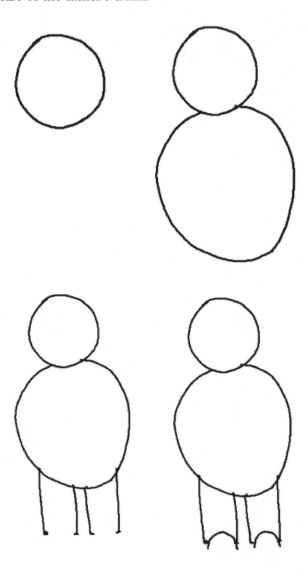

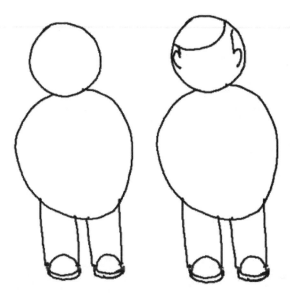

Unlike the previous drawings we made where we completed the face details first, we *focus* here *on the whole body before going into the details*.

This is to allow us to focus on the body proportions as we had already focused our attention on the face details earlier.

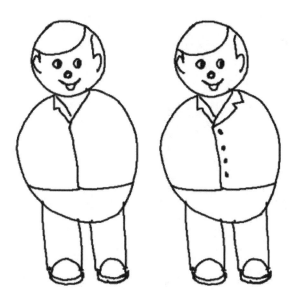

Add the hands next.

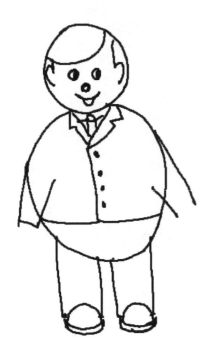

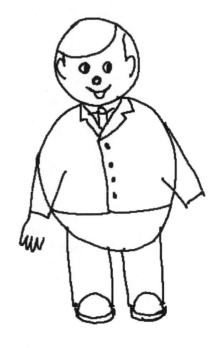

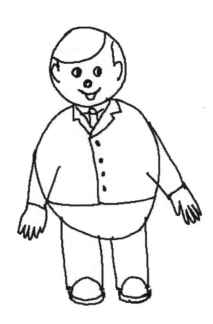

Draw her apron.

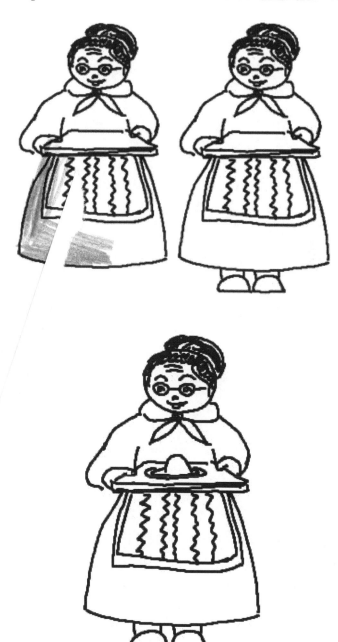

Let us change Grandma's hair.

One day she made her hair curly.

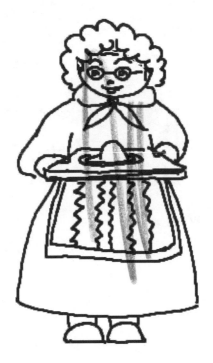

My Grandpa

Start with the grandpa's head first.

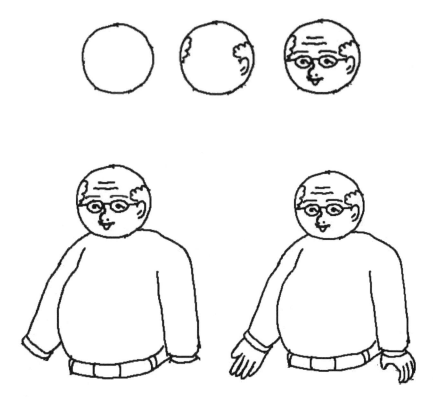

Do you know what grandpa holds in his hands?

Sometimes I see him holding a hammer;

At other times, I see him holding his hamster.

He loves taking care of his pet.

At other times, he takes good care of his net.

Grandpa was a fisherman.

But now, do you know what's in his hand?

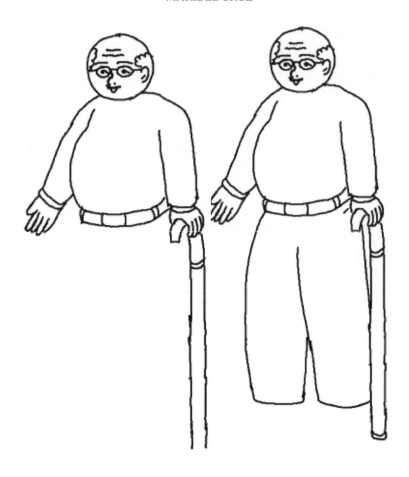

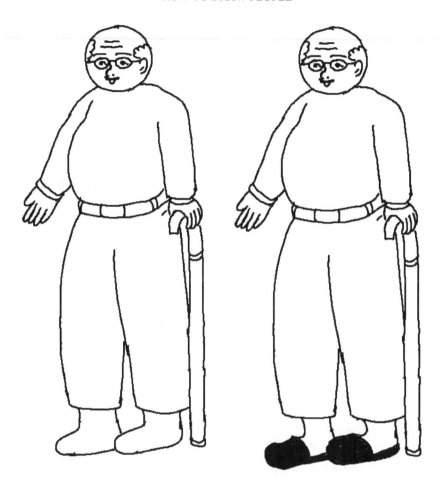

My Friends

Meet My Friend - Changying!

She is my friend - Changying.

Most of the time we enjoy playing.

Sometimes I cannot understand what she tells me but I love it when she smiles.

She always brings a beautiful fan and it is useful when we walk a few miles.

Do you have a friend like Changying?

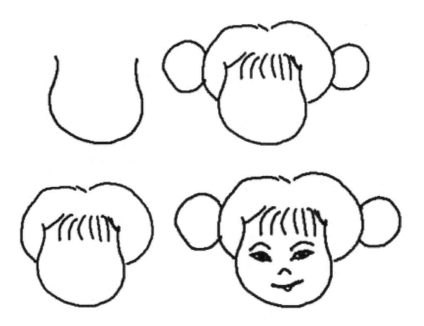

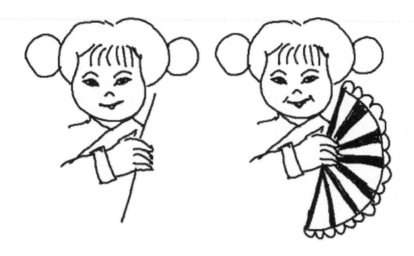

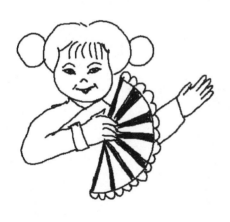

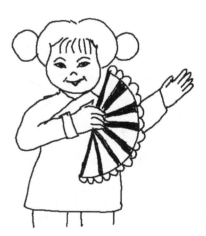

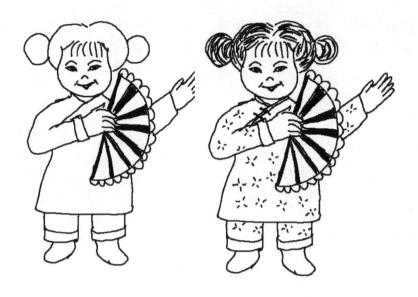

This is My Friend - Benton!

Do you like basketball like my friend Benton?

He dribbles and shoots his ball.

He runs and catches it swiftly.

Sometimes, he just sits and holds his ball with both hands.

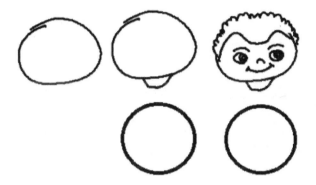

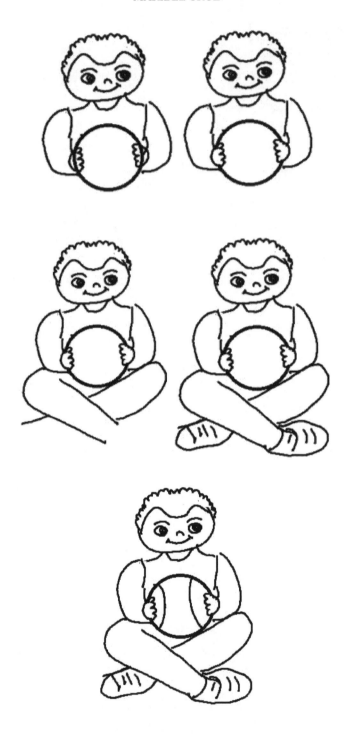

Say "Hi" to Scott!

Scott likes to run.

Scott loves to catch the ball with gloves on his hands.

Would you like to play with my friend, Scott?

He is nice and kind.

Can you describe my friend Scott?

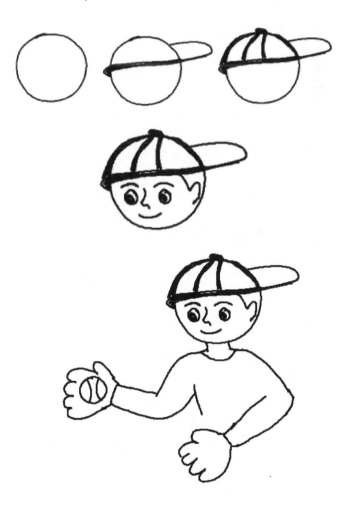

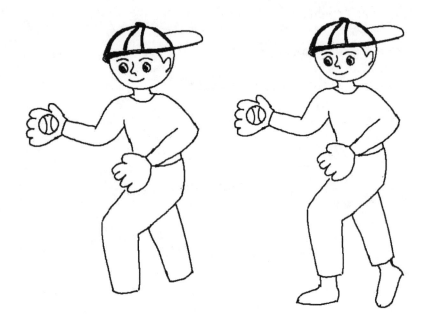

May I Introduce You to My Friend Mayumi?

Most often Mayumi is shy.

But she will always manage to smile.

I like my friend Mayumi - she is always kind to me!

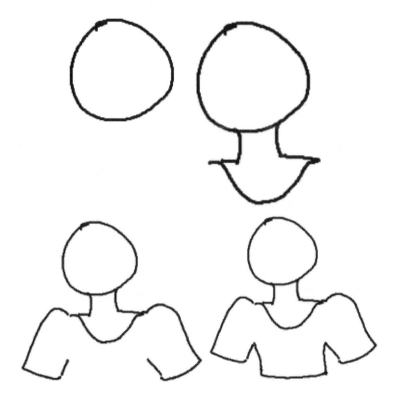

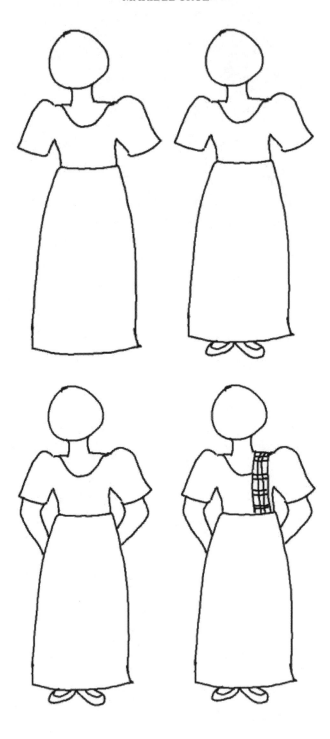

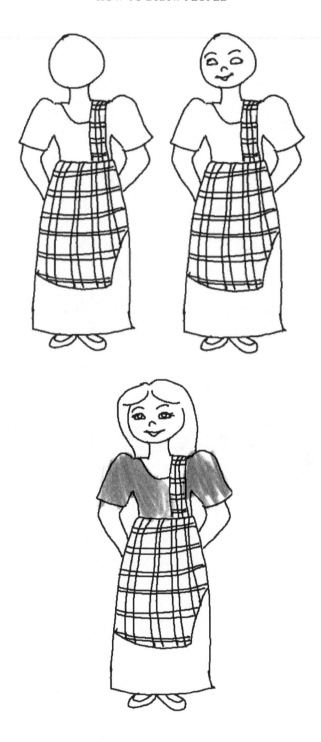

My Favorite Cartoon Character

Dora

Dora the explorer has a lot of fun. I love watching her explore the forest, rivers and other places.

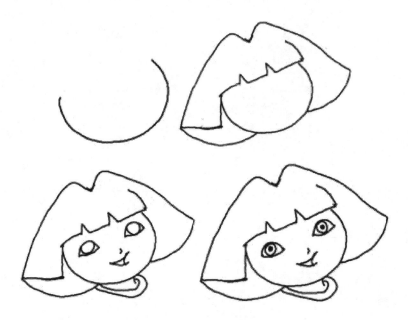

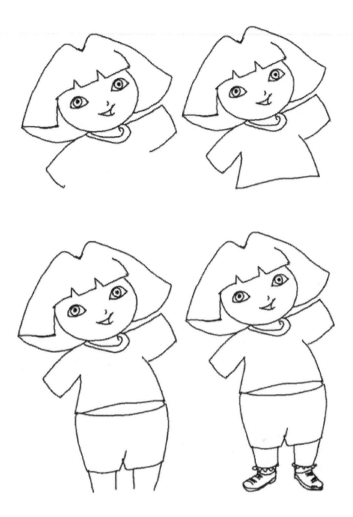

Hey, come on and join the fun!

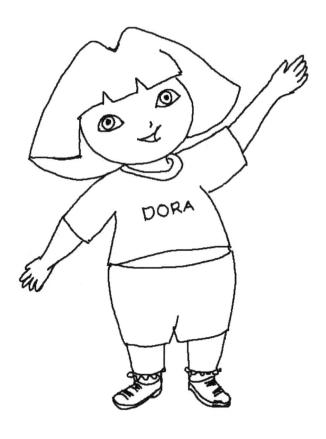

Diego

Diego is Dora's cousin. He has lots of fun activities too.

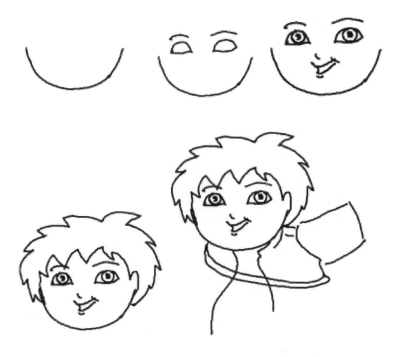

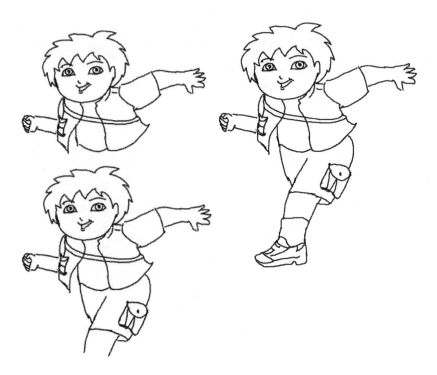

There's Diego - running and having fun.

He is always on the go to find thrill and discover things.

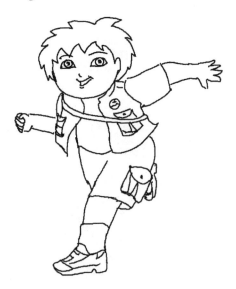

The People in My Society

Teacher

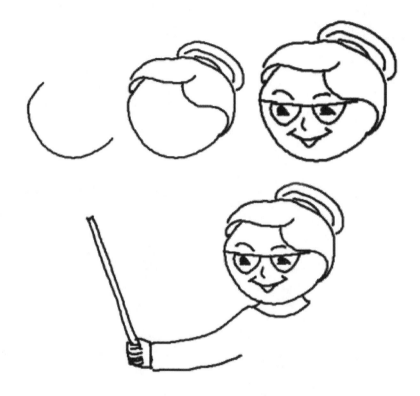

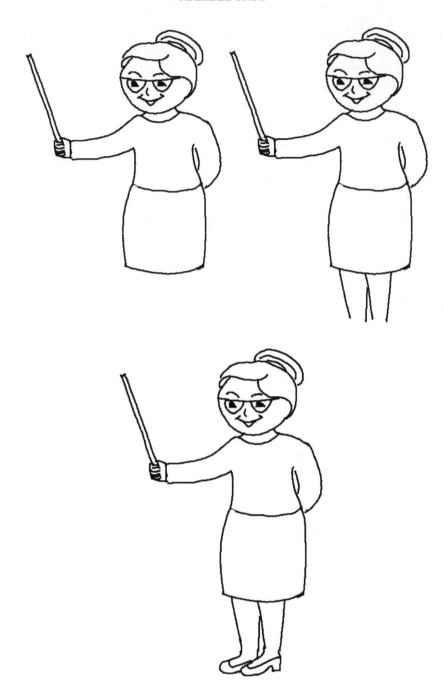

You may choose to draw a male teacher. You can also draw a teacher sitting on his/her table.

The key is to draw a lady or a man with a book or other things that a teacher usually holds on his or her hands.

You can draw the book this way:

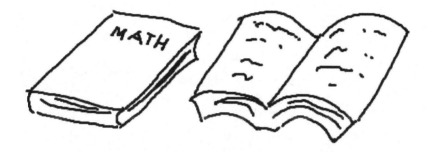

Policeman

Are you afraid of a policeman when he raises his hands?

Police officers are there to protect us from bad guys.

When I grow up I would like to be a policeman too.

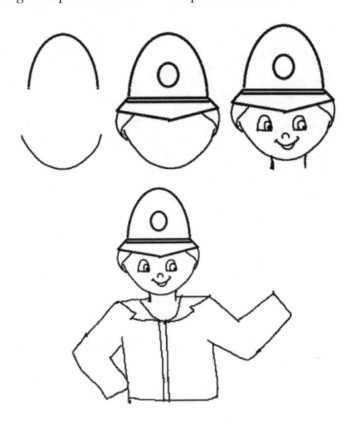

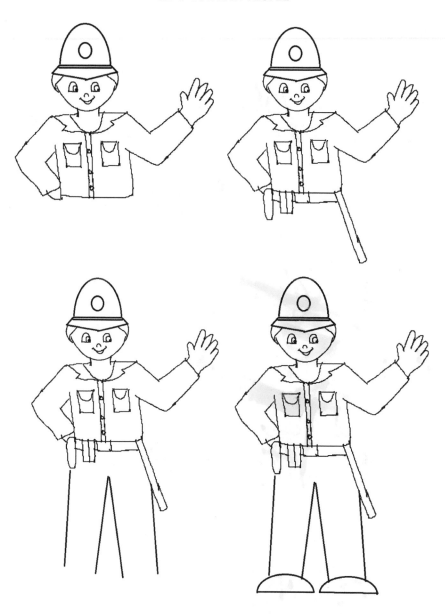

Nurse

Nurses wear something on their head.

Most of the time, their hair is short or neatly bundled or rolled.

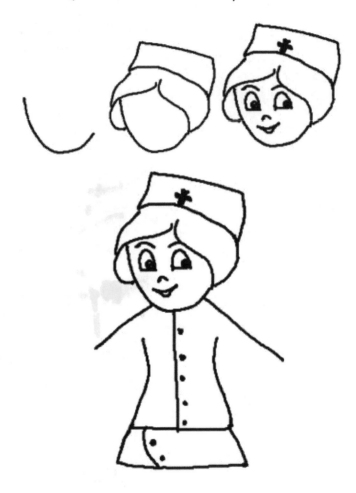

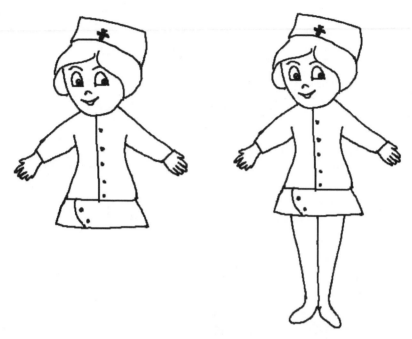

Now let's make different faces - all with kind and helpful smiles.

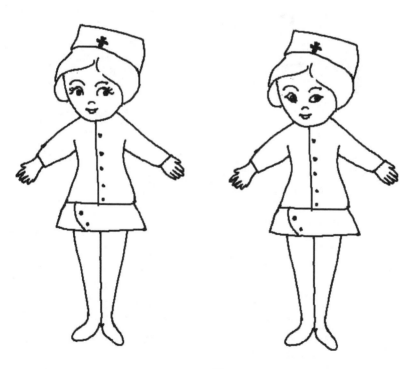

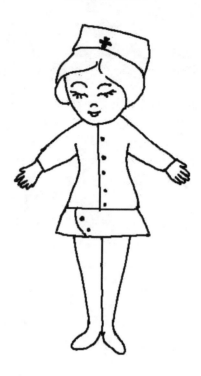

Doctor

I am scared of him because he looks grumpy.

Then I see him smile and he listens to my heartbeat with that small thing hanging on his neck.

Doctors wear this white gown with two pockets.

They always have the stethoscope on their necks too.

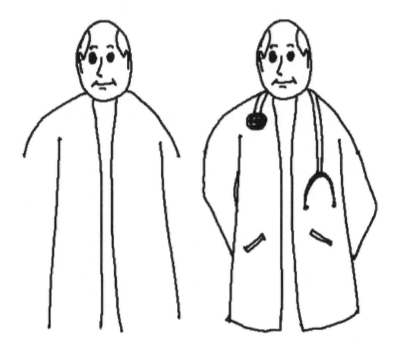

Doctors help us when we are sick.

They tell mommy what to do to make those pains go away.

Then we can start to play again.

Thank you Doctor!

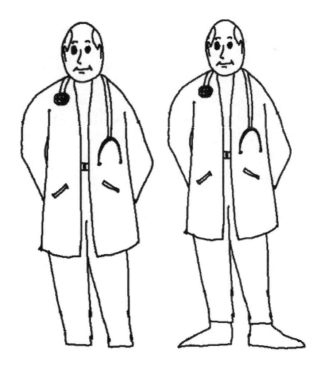

Carpenter/Builder

He builds our home, he builds the school.

He builds the hospitals, he builds the park.

With his hands and with his tools, he makes sure we have our shelter.

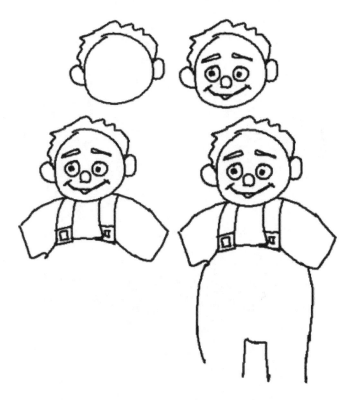

Now draw his working shoes or boots.

Let's now draw the tools and wood in his hands to show what he does.

Carpenters and builders use specific tools to do their job.

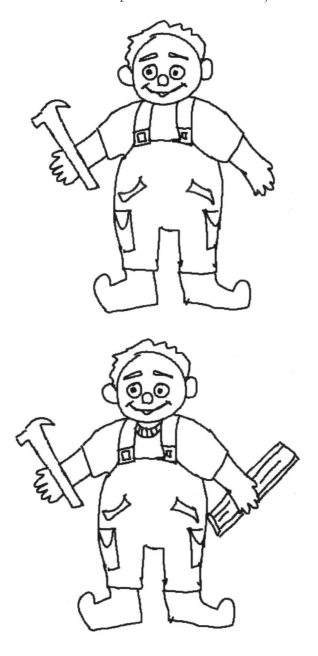

Baker

He wakes up early in the morning to bake.

He makes different breads and sometimes a pan of cake.

Once you can draw the hat well, all the other parts should be easy to draw.

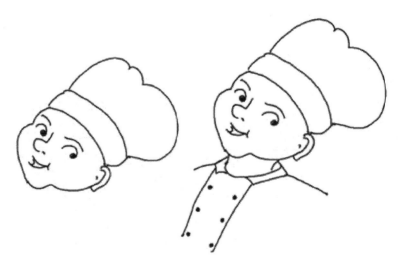

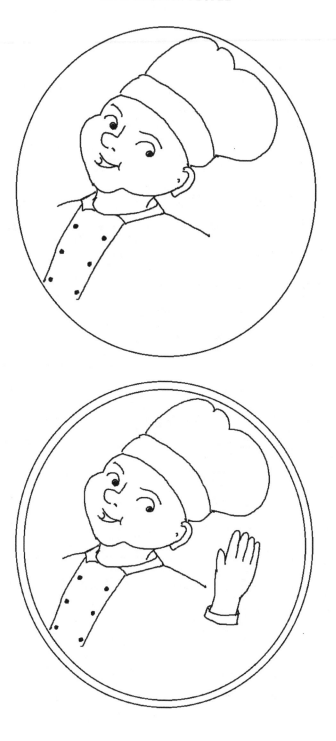

GETTING MORE
ADVANCED DRAWING
LESSONS

Congratulations! You did a wonderful job here. You've got this seal of excellence and smiles for the very beautiful drawings you have done!

But do not stop here! You can surely do much more. Through constant practice you can draw more amazing figures. If you can see it, you can draw it; if you can imagine it, you can draw it.

Take a look at how to draw more detailed faces of people in these two illustrations below.

Girl's Side View

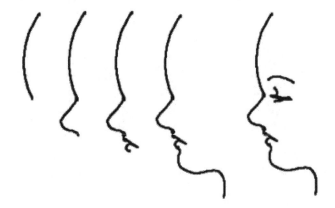

See how this drawing is made? It is not as difficult as you might think it is. You have already learned how to make curves.

Observe clearly the curves and master the proportions – know when to stop sliding your pencil and shift to another direction.

You need to do it over and over until you are happy with your output.

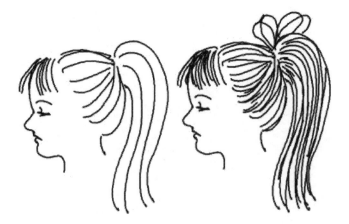

Make the hair and the hair ribbon. You can choose to make the hair

simpler. You can make it curly if you like.

If you have tried recreating this drawing ten times and you are still not happy about the drawing you made, do not feel sad. I did not do well until I tried it more than a hundred times.

Girl's Front View

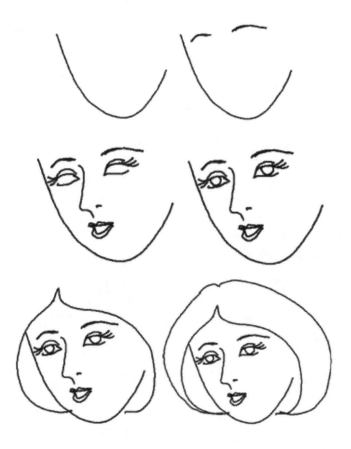

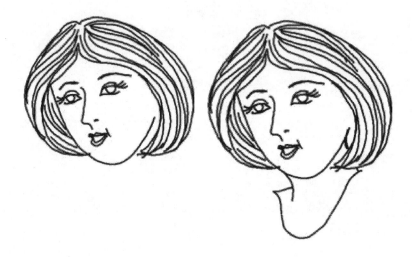

Good luck! Keep practicing!

ABOUT THE AUTHOR

Maribel Cruz grew up in a remote village where there was lack of techno gadgets to let her mind explore things and express her ideas. Before Maribel started writing, she was already drawing. This was the influence of her older sister who is really good at pencil drawing, sketching and color painting. At the age of 8, young Maribel Cruz joined art competitions – poster making and water color painting.

Maribel was ten when she first represented her school in a provincial poster making competition. Earning a gold medal, she joined the regional science fair poster making competition.

This book is a summation of the learning experience that Maribel Cruz has gone through. It is supposed to simplify the learning process for kids and inspire them for expression of their feelings through the art of drawing.

Made in the USA
San Bernardino, CA
18 December 2019